The Book of "Unnecessary" Quotation Marks

THE BOOK OF "UNNECESSARY" QUOTATION MARKS

A Celebration of Creative Punctuation

By Bethany Keeley

CHRONICLE BOOKS

SAN FRANCISCO

Text copyright © 2010 by Bethany Keeley.
All rights reserved. No part of this book may
be reproduced in any form without written
permission from the publisher.

All photographic copyrights belong to the
individual photographers.

Library of Congress Cataloging-in-Publication
Data is available.

ISBN: 978-0-8118-7645-2

"Manufactured" in China

Designed by "Catherine Grishaver"

10 9 8 7 6 5 4 3 2 1

Chronicle Books LLC
680 Second Street
San Francisco, CA 94107

www.chroniclebooks.com

CONTENTS

INTRODUCTION

QUOTATION MARKS AND THE "NEW" "YOU"

Today is the first day of the rest of your "life," because you are reading this "book," which will change the way you view punctuation forever. Before, you may have used quotation marks sparingly—for example, when quoting someone. Perhaps you thought there were grammatical rules, limiting the possible occasions for using the humble quotation mark. That may once have been the case. But from my experience curating the "Blog" of "Unnecessary" Quotation Marks, I can tell you that people are developing new and exciting ways to use the quotation mark every day. In fact, there are literally "millions" of ways to use these little word adornments to express yourself.

They are much more than mere punctuation. They can serve so many purposes! Quotation marks are like the character actors of print, playing a wide variety of roles. They're the little tchotchkes that spruce up an otherwise plain statement, the word dimples that mark an adorable pun, or the punctuation equivalent of the ironic hipster mustache, assuring your audience that you are WAY too cool to mean that particular word sincerely (or, perhaps, that you are cool enough to know that mustaches are the new goatee).

Not sure how to start using quotation marks yourself, or how to interpret their myriad meanings? Well, don't be frightened—that's what this book is here to teach you. After some practice, you'll find that quotation marks are merely the makings of a fun linguistic puzzle for you to solve. To help you on your way toward better integrating quotation marks into your life (and understanding those you encounter on a day-to-day basis), I've assembled a list of the various ways quotation marks are used in the world around us. Of course, new meanings for the quotation mark are popping up every day, so you'll want to keep track of your own findings and discoveries, too (see "Proper Quotation-Mark-Spotting Gear & Attire," pg. 17). The pages that follow contain some basic categories of quotation mark use that will guide you through the rest of this book.

USE: Quotation

EXPLANATION: A very popular historical use for the quotation mark, a quotation is something somebody once said somewhere. For example, "I have a dream" is something Martin Luther King Jr. said once.

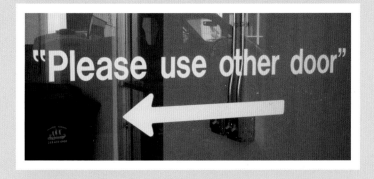

Here's a classic quote. Who said that? Yeats?

USE: Nickname

EXPLANATION: A person's or place's nickname or assumed name is often marked by quotation marks. Just ask my friend "The Drooler."

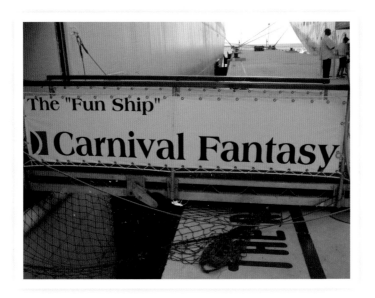

This boat is nicknamed "Fun Ship," which has a much better ring to it than its original nickname, "Drudgery Vessel."

USE: Sarcasm or disbelief

EXPLANATION: Quotation marks are often used to indicate the opposite of the word that they quote. For example, those cookies are so "healthy."

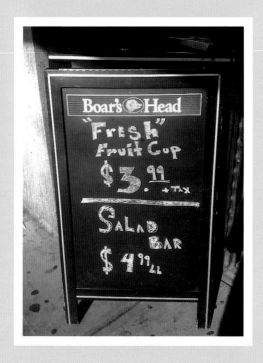

Here, it depends on your definition of "fresh."

USE: Title

EXPLANATION: Songs, poems, and other short pieces of art are often marked by quotation marks. For instance, you might ask someone to come and view a performance piece titled "Please Close Door."

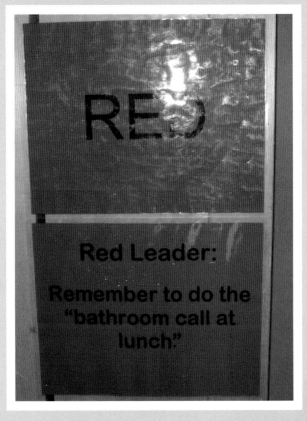

"Bathroom call at lunch" is a little-known *Star Wars*-themed dance. The best part is when you blow up the Death Star.

USE: Euphemism

EXPLANATION: Sometimes we are too delicate to be explicit. Quotation marks can help even the most squeamish person say dirty or inappropriate things comfortably. You know, like when your parents stay home alone to "clean up the place."

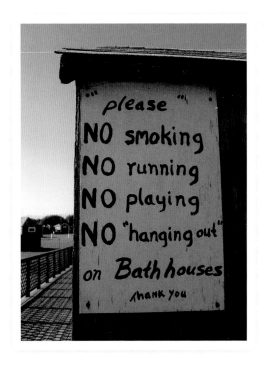

Basically, don't do anything. And really don't do anything that "hanging out" might be a euphemism for.

USE: Slang
EXPLANATION: Popular slang terms are often placed in quotation marks—this is especially common when the writer considers herself too elite to use said term seriously. For example, when your pretentious friend asks if you are having "fun" shopping for some "bling."

USE: Turn of phrase
EXPLANATION: As with slang terms, quotation marks can help clarify when you don't mean something literally. Nobody is actually "putting lipstick on a pig," and when you win three hands of poker in a row, you do not literally ignite, even if you are "on fire."

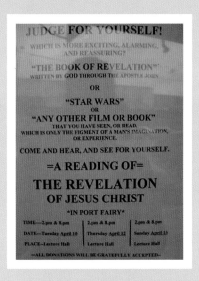

You know, "Any Other Film or Book," as the kids say.

USE: Pun

EXPLANATION: In case your joke is so subtle (or terrible) that you don't think people will notice the pun, quotation marks can serve to elicit the groan you are looking for.

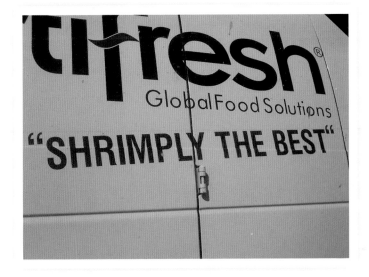

In this case, the quotation marks are like a street sign:
Warning! Bad pun approaching!

USE: Code

EXPLANATION: When dealing with secret government agencies or illegal activities, sometimes you have to use code words—put them in quotation marks to make them more effective. For example, ship the "gift" to my "cousin's" house in D.C.

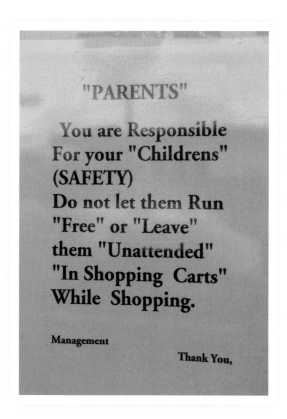

This sign is clearly speaking in code about, um, something.

USE: Insincerity

EXPLANATION: Quotation marks are a good way to pretend to mean something that you don't mean, or to make "promises" that you don't think you'll be able to keep. Like, how this crappy DVD player that I'm selling out of the back of my truck is "100%" not stolen and is "backed by a lifetime warranty."

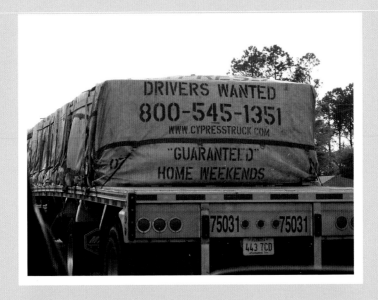

Yeah, home weekends "guaranteed"—they really "mean it."

USE: Symptom of descent into madness

EXPLANATION: Sometimes quotation marks are simply part of the insane scribblings of a deranged mind, or have symbolism that is meaningful only to the writer and the other voices in his head.

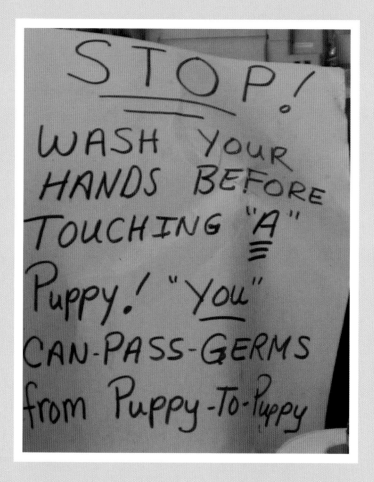

Now that you have these common interpretations under your belt, you are probably feeling pretty confident about your ability to recognize quotation mark use in your everyday life. The celebration isn't over, though. The rest of this book will give you more examples of the use and misuse of quotation marks, sensical and non, that will enlighten and enliven your shopping, travels, and social interactions. Creative and exciting uses of quotation marks can pop up where you least expect them: keep an eye out as you go about your day, shop, eat, work, drive, and, um, "do your business."

PROPER QUOTATION-MARK-SPOTTING

GEAR & ATTIRE

WHAT DO YOU NEED TO FIND AND INTERPRET THE CREATIVE USES OF QUOTATION MARKS?

- ➡ safari vest with lots of pockets for your gear
- ➡ some kind of helmet (for safety)
- ➡ camera (one that also has video is best, in case you catch someone making finger quotes in their speech)
- ➡ notebook for documenting and categorizing finds
- ➡ tape recorder as notebook backup
- ➡ laser pointer
- ➡ headlamp
- ➡ kazoo

"UNNECESSARY" QUOTATION MARKS

AT

" WORK "

Where are you most likely to find sarcasm, disingenuousness, and coy euphemisms? That's right, on the job. With your "qualified" boss and "appreciative" co-workers who are "interested" in your "safety," the workplace atmosphere is ripe for the creative use of punctuation. No matter what your career, you have to be on the lookout for hidden meanings at every turn.

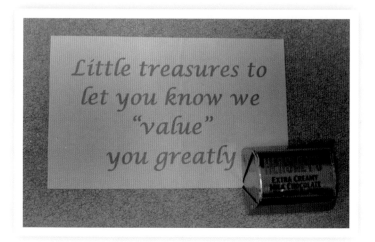

At this office, your "value" is equal to one piece of candy.

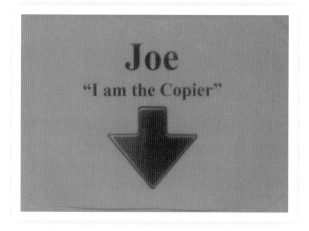

Okay, Joe—whatever you say.

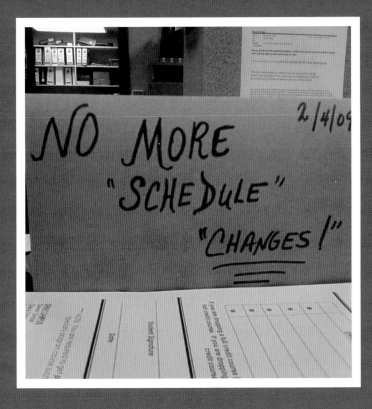

Otherwise known as "funny business" or
"interoffice" "affairs."

august

THE HOME DEPOT

Learning C

Clinic	Mon	Tue	W
Toilet Repair	"Jesse"		
Interior Paint	"Daniel"		
Ceramic Tile	"Ken"		
Wiring Devices	"Jack"		
Repairing Drywall	"Ed"		
Faucet Repair	"Jesse"		
Exterior Paint	"Daniel"		

These are all the same person,
dressed in different outfits.
The wigs are hilarious!

enter Clinics

	Thu	Fri	Sat	Sun
			9 AM	
			10 AM	
			11 AM	
			12 PM	
			1 PM	Small Bath Update "Jesse"
			2 PM	Closet Organization "Sabrina"
			3 PM	Safety & Security "Jack"

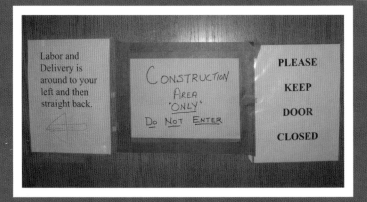

Like construction sites.

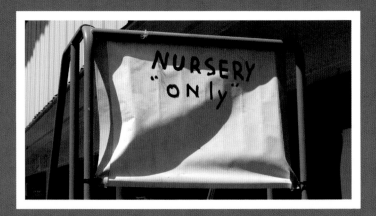

And nurseries.

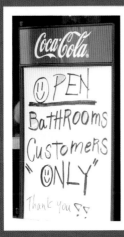

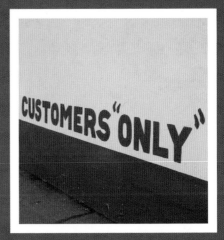

And customers.

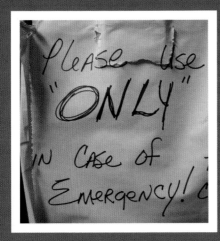

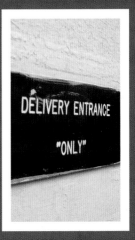

And doors.

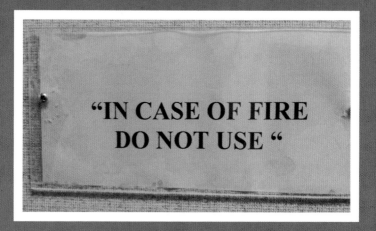

PLEASE "DO NOT" remove faxes from the machine unless you are delivering it to the person it was meant for! If it is an "outgoing" fax, send it or put it back where you found it.

Here, a subtle dare to remove and hide personal faxes.

"IN CASE OF FIRE
DO NOT USE "

As a famous man once said, "In case of fire, do not use." And then he made the noise backward quotation marks make.

In the workplace, we're often forced to make promises that we can't keep. "I'll have that expense report to you by Monday," for example, or "I won't ever replace you with a machine." Quotation marks are a great way to make those promises without being bound to them. Just put it in quotes, and it's clear that you only kind of mean it.

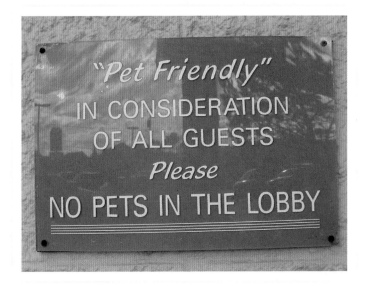

"Pet friendly" is secret code that pets are not allowed here.

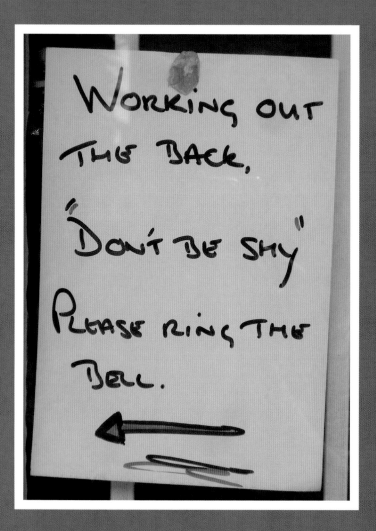

At this office, the employees put on a great dance routine to the classic tune "Don't Be Shy"—customers get to play the tambourine.

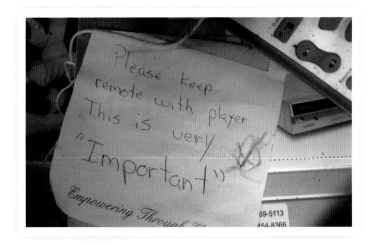

There is nothing important about this.

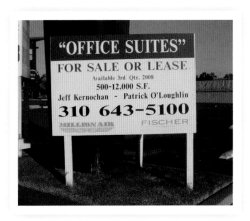

A not-so-subtle wink to the renters who would use the space as a drug front.

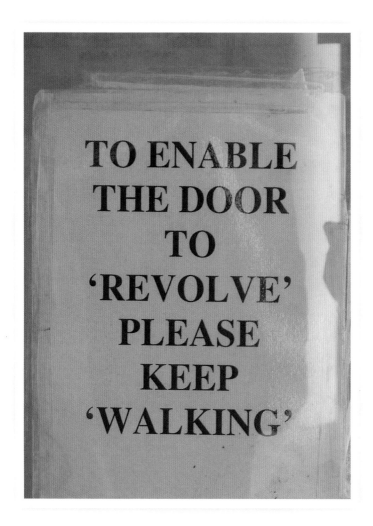

TO ENABLE
THE DOOR
TO
'REVOLVE'
PLEASE
KEEP
'WALKING'

This sign is making fun of the way you walk.
Because, seriously, the way you get from place to place
is more like shuffling or stumbling.

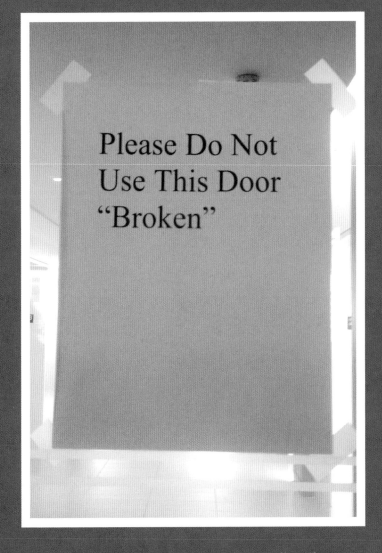

Please Do Not
Use This Door
"Broken"

Actually, it's my private door that only I am allowed to use.

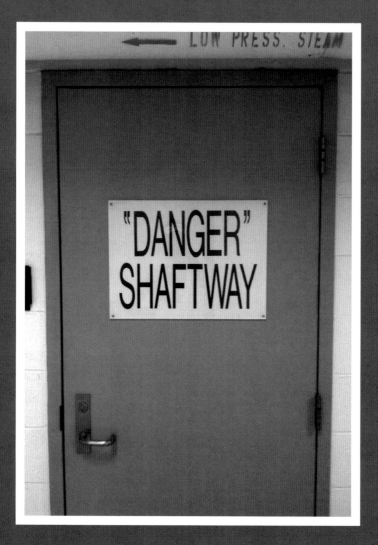

Maybe some people would consider a shaftway dangerous, but I laugh in the face of "danger." Hahaha! Ha.

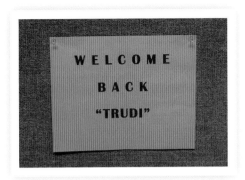

When in doubt of someone's name, put it in quotation marks. That way, you can always pretend it's a new nickname you just made up.

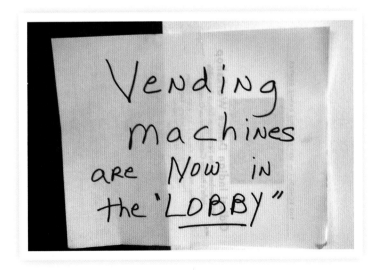

It's a sad excuse for a lobby.

"HiRiNg"
SeRUeR

Pls come iN side &
apply for job.

Call tel # 404-313-6655

Tokyo Japanese RestauranT

Looking for someone to work for free.

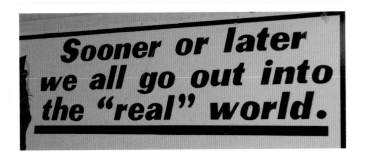

Well, maybe it's a simulated world run by robot computers. But, in any case, sooner or later you'll go out into it.

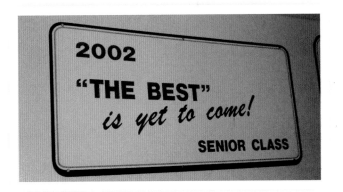

"The Best" equals "a dead-end job," "ungrateful children," and "bankrupt Social Security in your old age."

"UNNECESSARY" QUOTATION MARKS

" AT THE "

STORE

It's hard to know what you're buying when you go shopping these days. Some stores might have policies that only apply to some "people," or "products" that are only for sale on one of the "7" days in the week. Deciphering rules, regulations, and terms of sale may have been a challenge in the past, but not after you're familiar with our good friend the quotation mark.

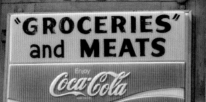

"GROCERIES" and MEATS

Enjoy Coca-Cola

SPENCER

Come s

IN BUSINESS
SINCE
1940
724·3414

VISA

Cheese Burger $2.00
Chicken Breast $2.00
Pizza Burger $2.50

Fries $1.50
Tator Tots $1.50
Cheese $1.50

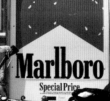

Marlboro
Special Price

Nothing like food
made out of "groceries."

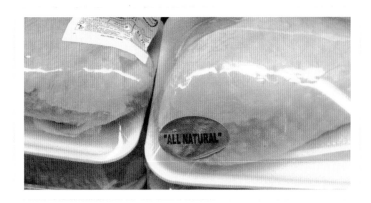

Certainly, not EVERYTHING about these chickens' lives was natural. Domestication, for starters.

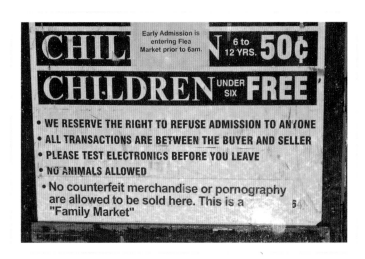

This is obviously a front for the Mob.

"Store" is Australian for "store."

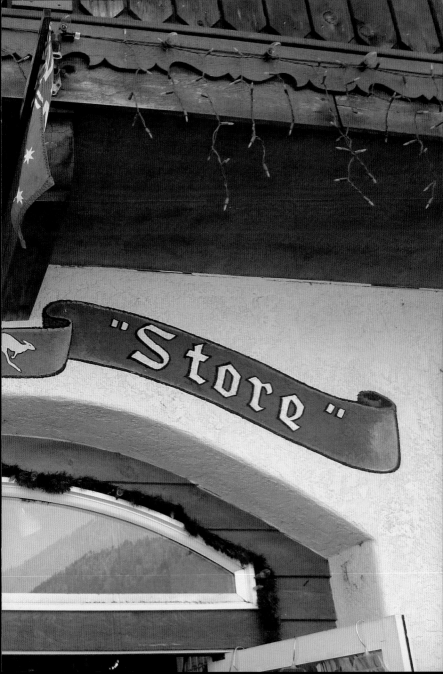

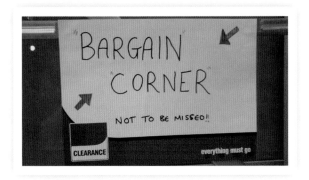

As this sign proves, tiny quotation marks can be used to daintily make innocuous words into dirty euphemisms. I mean, "bargain" "corner"? Gross!

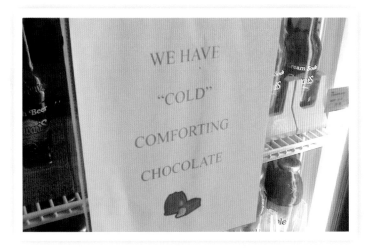

You keep using that expression.
I do not think it means what you think it means.

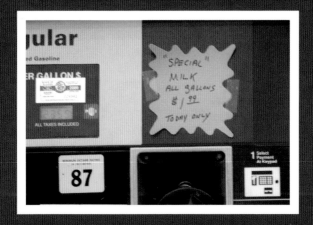

Want to know what makes the "special" milk so "special"?
Pot.

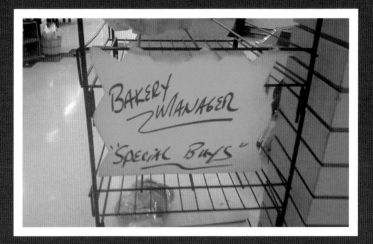

Want to know what makes the "special" buys so "special"?
Unicorn kisses.

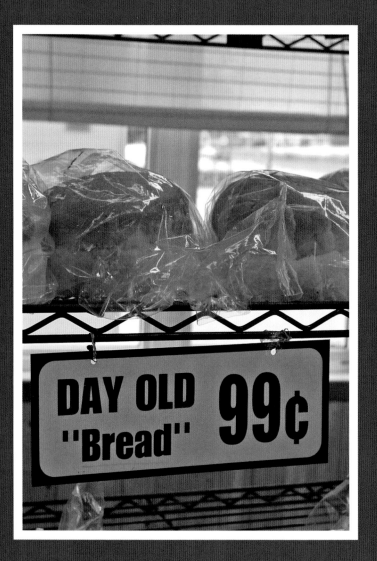

Or whatever.

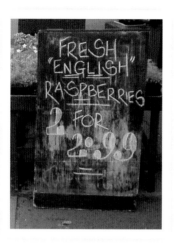

Don't tell the raspberries how obvious it is that English is their second language. They would be so embarrassed.

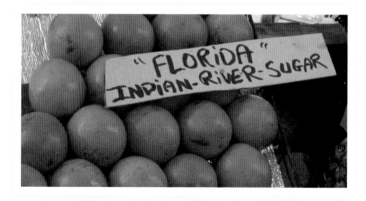

"Florida" is the nickname of the person who grew these oranges.

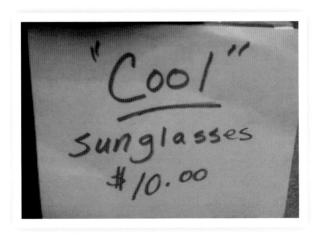

Don't let the sign fool you—
these sunglasses are totally square.

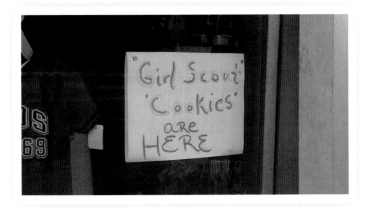

If by "Girl Scout" you mean "Boy Scout," and by "Cookies"
you mean "magazine subscriptions," then yes. They are here.

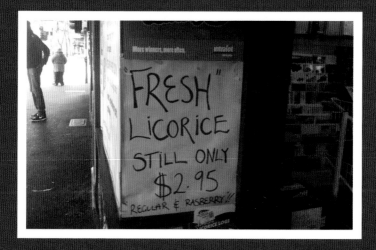

Candy isn't one of those things where freshness is really important, so some approximation of fresh is acceptable here.

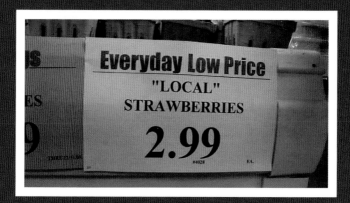

These strawberries are from the same continent we live on. They are "local."

"HELPFUL" HINTS

Some stores prefer to use nonbinding numbers to set their hours and motivate customers.

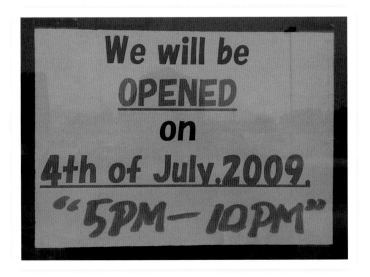

We will be
OPENED
on
4th of July,2009.
"5PM— 10PM"

For example, the hours here are flexible. It depends on when the teenagers who are running the place get bored enough to either leave or fall asleep.

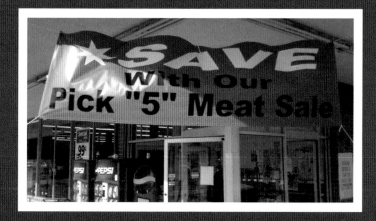

If they are all cow parts, that still counts.

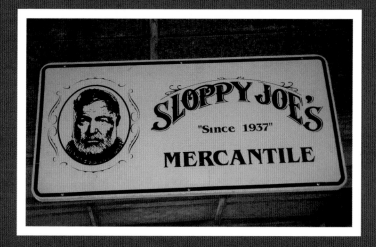

Sloppy Joe liked to walk around saying "since 1937."
Sure, it's a weird catch phrase, but that's Joe for you.

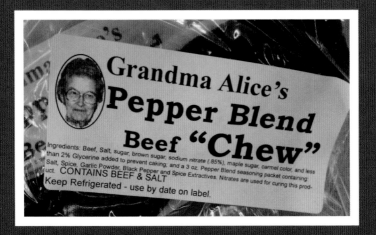

So tough it's actually more of a "gnaw."

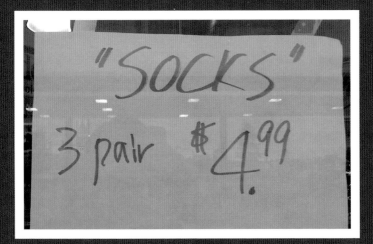

Pants with the leg holes sewn together.

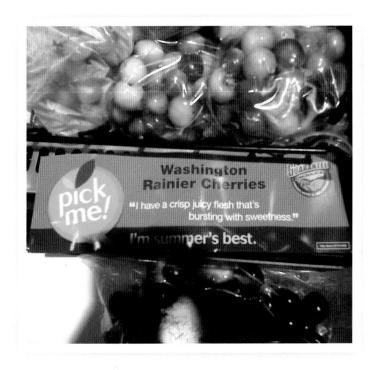

Aaah! Talking cherries!

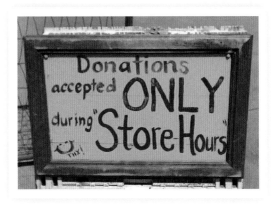

When are "store-hours" you ask?
Depends on if they want your crap or not.

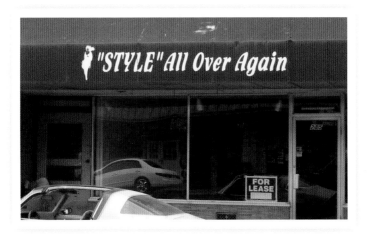

Among the "stylish" clothes sold here: T-shirts with shoulder
pads, stirrup pants, orthopedic shoes, banana hammocks.

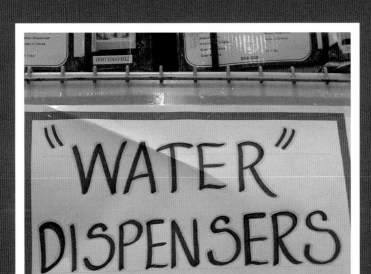

These are for cocktails, obviously.

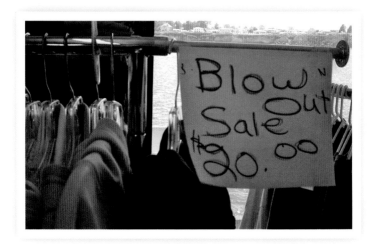

Anything you blow on is on sale.

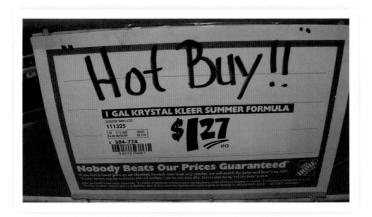

"Hot Buy" is just a colloquial term—Krystal Kleer Summer Formula is usually served cold. Like gazpacho.

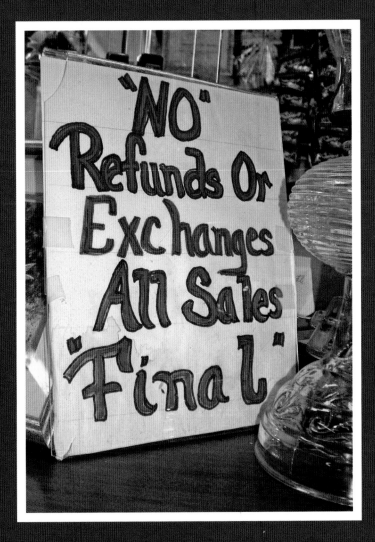

A "final" sale is one that might arbitrarily be eligible for a refund.

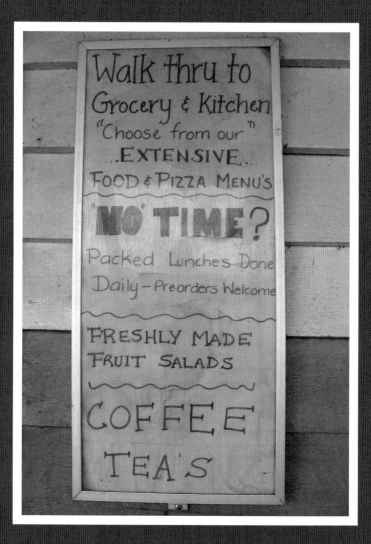

Even in the store, the use of quotation marks has been known to defy explanation from time to time.

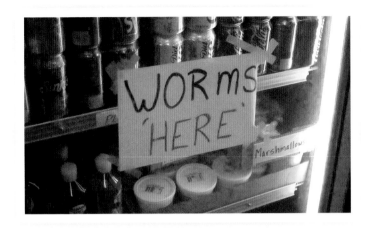

The worms are here in the store, not here in these soda cans.
That would be a real can of . . . never mind.

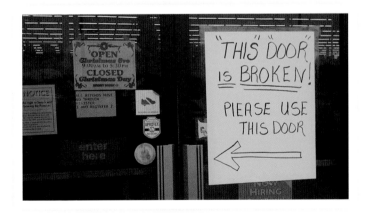

You can only enter "this" "store" if you can
decode "this" "sign."

"UNNECESSARY" QUOTATION MARKS

ON THE

"MENU"

If you thought your quotation mark problems ended at the store, you would be sorely mistaken. Prepared foods are full of imposter ingredients and tricky adjectives. They are frequently dished up by chefs uncertain about their own ingredients and served to you by a perplexingly vague wait-staff. Interpreting the unsettling questions that quotation marks raise in this area will help you learn which "foods" to order and which "restaurants" to avoid.

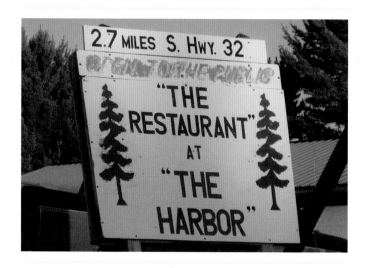

This could be any restaurant, anywhere.

It's an approximate number of days.

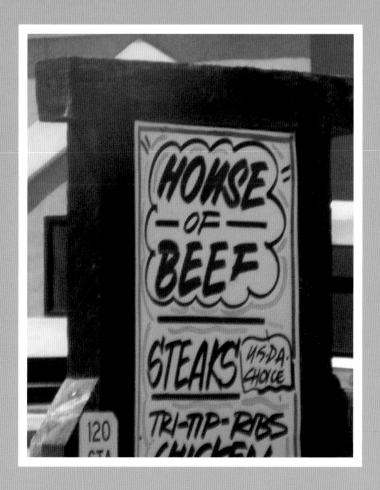

This is really more of a restaurant of beef.

Isn't that what you kids call "sandwiches" these days?

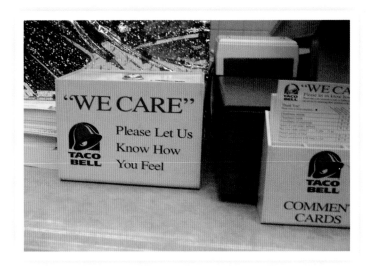

Sure you do.

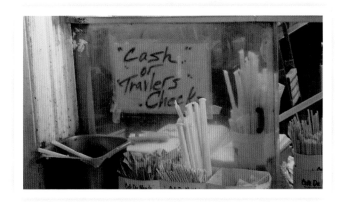

Pretend money welcome here.

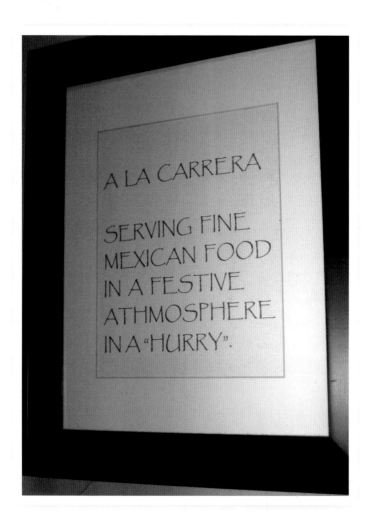

The waiters will pretend to be frazzled when they finally get to your table.

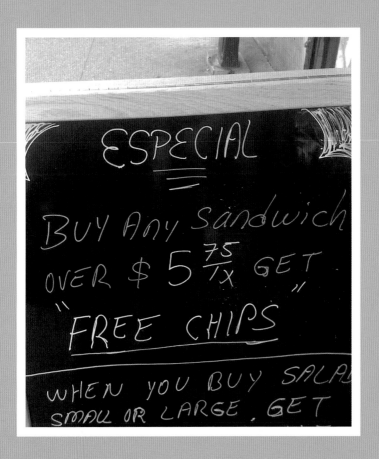

There is no such thing as free chips.

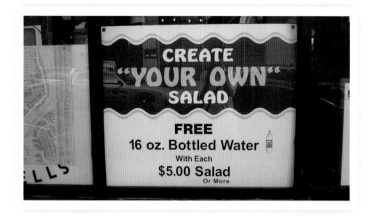

Here, you get to create another customer's salad.

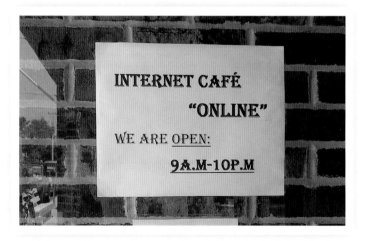

Let's write a word that has something to do with the Internet.
"Online" seems good enough.

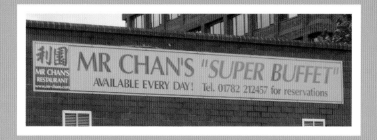

By day it's a mild-mannered salad bar.

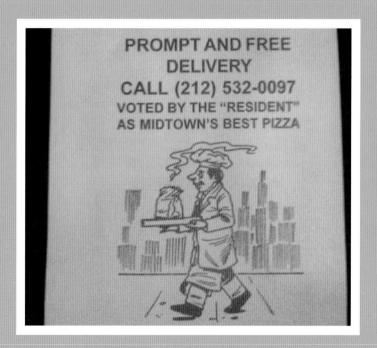

"Resident" is another term for "owner of the restaurant."

Salad's

Garden Salad	$5.25
Ceasar Salad	$5.50
Greek Salad	$6.50
Taco Salad	$6.75
Grill Buffalo Chicken Salad	$7.25
Apple Cramberry Walnut Salad	$6.25
Mandarin Orange Almond Salad	$6.25

"ADD"

Grilled Chicken	$2.40
Chicken Salad	$2.40
Tuna Salad	$2.40
Palmitos Salad	$2.40

"DRESSIN'S"

Italian - Balsamic Vinaigrette
Greek - Honey Mustard
Blue Cheese - Fat Free
Roasted Sesame - Parmesan
Pepper Corn and French...

ADD A SIDE Salad TO ANY
Sandwich or Soup $2.50

Empanada's (one Grande) $3.50
Empanadas (Q) Small $4.50

"Sandw

Roast Tunkey
Thanksgiven
Cuban Sand
Tuna Salad
Chicken Salad
BLT Sandwic
Grill-Chees
Grill Ham
Chacarero
Chicken Parm
"Soup a Half
Clu
Fresh Cut Tu
"Wra
Buffalo Ch
Chicken Ce
Chicken Fa
Veggi w
Pan
Grilled Eggp
Grilled Chick
Tom
Grilled Eggpl
Grilled Vegg
Broccoli a

Now "Beer

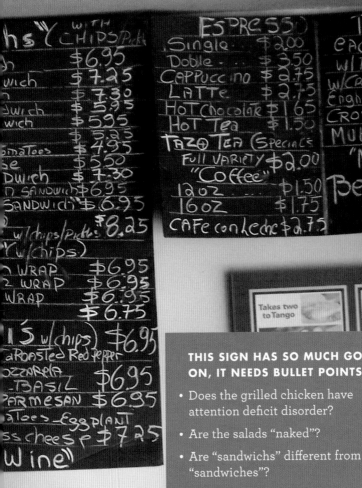

hs" WITH CHIPS/Pickle
h $6.95
wich $7.25
n $7.30
wich $5.95
wich $5.95
$5.95
omaToes $4.95
e $5.50
Dwich $7.30
n SANdwich $6.95
SANdwich $6.95
$8.25
w/chips/Pickle
(w/chips)
WRAP $6.95
2 WRAP $6.95
WRAP $6.95
$6.75
i's w/chips $6.95
aRoasted Red Pepper
ozzarela $6.95
-Basil $6.95
Parmesan $6.95
aToes-Eggplant
ss cheese $7.25
Wine"

ESPRESSO
Single $2.00
Doble $3.50
Cappuccino $2.75
Latte $2.75
Hot Chocolate $1.65
Hot Tea $1.50
Tazo Tea (Specials)
Full Variety $2.00
"Coffee"
12 oz $1.50
16 oz $1.75
Cafe con Leche $2.75

Bagels
each $1.
w/ Butter $
w/ Cream Cheese $
English Muffin
Croissant $
Muffins $
"Now"
Beer/Wi

THIS SIGN HAS SO MUCH GOING ON, IT NEEDS BULLET POINTS:

- Does the grilled chicken have attention deficit disorder?

- Are the salads "naked"?

- Are "sandwichs" different from "sandwiches"?

- What's the difference between Now "Beer/Wine" and "Now" Beer/Wine?

- Or should we just give in, and hope that the "coffee" has a little Irish in it?

How do you know if something at a restaurant is good?
First, check for quotation marks:

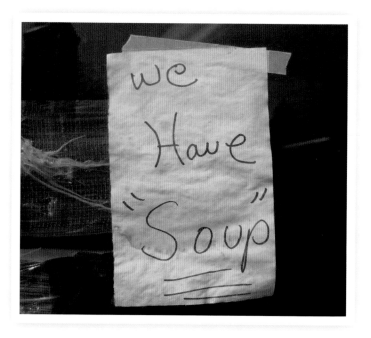

Three little words that become deeply unsettling with the
addition of quotation marks.

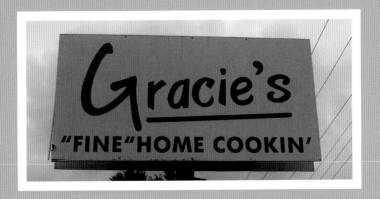

How's the cooking at Gracie's? Survey says . . . "fine."

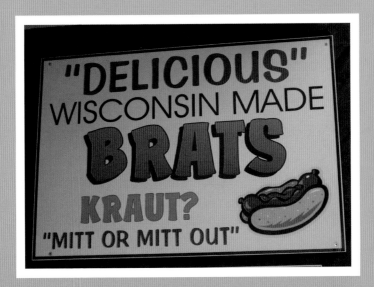

Sounds "yummy."

It's difficult to know what you're actually ordering when the ingredients are shrouded in quotation marks. Figuring it out takes practice and a keen eye:

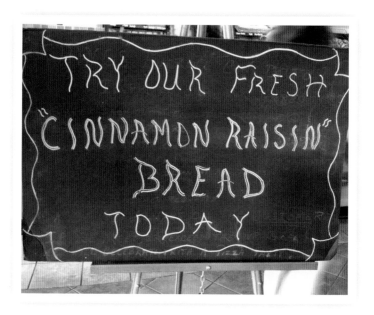

For instance, this bread probably secretly has chocolate chips in it.

sprouts and red onion with a New Orleans style
remoulade sauce **11.95**

The Northshore Club

A triple decker with smoked turkey, bacon, cheddar and
swiss cheese with "the works" on sourdough bread
with french fries **11.95**

The Hanalei Sailor

a.k.a. The Mambo Mikey. A Reuben grilled with a
"double" portion of corned beef, sauerkraut, and swiss
cheese on rye bread with russian dressing **11.95**
"Turkey Reuben" a lighter version of the original **9.95**

Gourmet Deli Sub

Ham, salami, swiss, provolone, pepperoncini,
lettuce, tomato, sweet red onions and vinaigrette

"Double" of nothing is still nothing. And that makes the
"Turkey Reuben" a lighter nothing sandwich. Don't even ask
me what constitutes "the works"—you don't want to know.

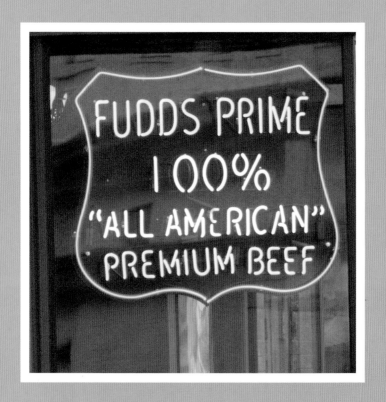

This beef recently immigrated.

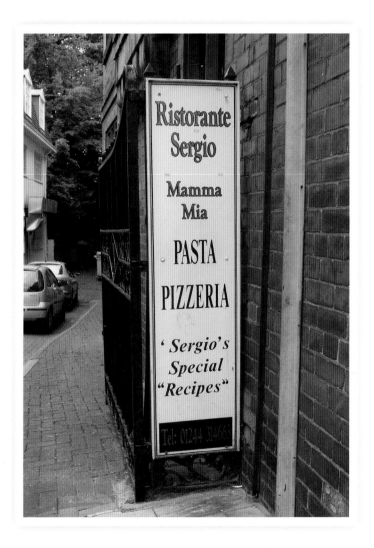

Well, okay, everything on the menu comes from the same giant can of Food Product. That's still a "recipe."

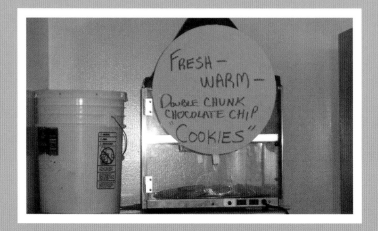

In this restaurant, anything with a circular shape is considered a "cookie." They even have a meat-lover's "cookie."

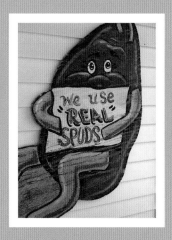

Yeah, that picture makes it look like those potatoes are "real."

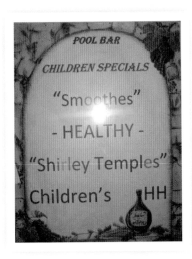

Why are those kids stumbling around the pool?
Must be the "smoothes."

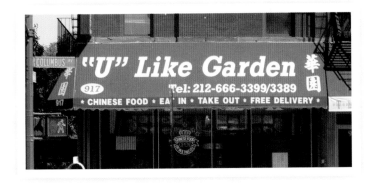

"U" like it. Kind of like another version of you,
but with worse taste.

DOUBLE
BACON BURGER
BACON CHEESE BURGER
CHICKEN SANDWICH OR GARDEN BURGER
CHICKEN NUGGETS HOT DOGS

HOT DOG
CHILI DOG
KRAUT DOG
CHILI CHEESE DOG
NACHO CHEESE DOG

OLD FASHION `ALL BEEF GRILLED` HOT DOG
CORN DOGS
`FRESHLY MA

CORN DOG
CAJUN CORN DOG `SPICY`
FRIES

FRENCH FRIES
CHILI FRIES
CHILI CHEESE FRIES
NACHO CHEESE FRIES
GARLIC FRIES

ITALIAN or LINGUICA "sausage" ANDWICH
5.99 PLUS TAX
ROLL
SAUSAGE

Lots of items on this menu seem just a little bit . . . off.

4.69	CORN DOG
4.69	HOT DOG
3.49	
2.79	
3.29	ARTICHOKES
3.29	ZUCCHINI
3.59	MUSHROOMS
3.29	VEGGIE COMBO TRAY
4.39	EXTRA RANCH
3.49	CHOWDER BREAD
3.79	CHILI BREAD
	CUP OF CHOWDER
.99 LG. 4.49	CHILI BEANS
4.49	
4.99	
4.49	
5.49	BIG DOUGHNUT
	GARLIC BREAD

FRIED V

SOUP OR C

MISC

ITEMS PLUS TAX

Barbecue
BEEF
SANDWICH

5.99
PLUS TAX

ROLL

"UNNECESSARY" QUOTATION MARKS

ON THE

" "

ROAD

Traveling across the country—or even close to home—offers a great opportunity to open your eyes to new sights, sounds, and surprising uses of quotation marks. Along the way, you'll get to experience the quirky slogans and creative puns of the open road.

"HELPFUL" HINTS

Billboards and businesses along the highway have long honed the art of using the quotation mark to make unsettling and confusing statements.

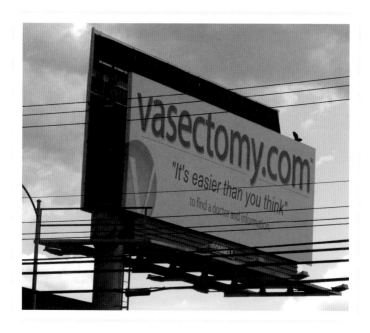

Vasectomy: exactly as hard as you think.

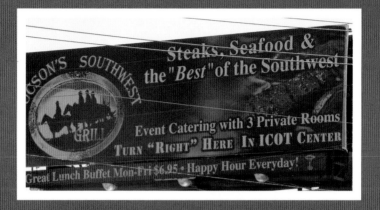

Wait, turn "right" here? As in "right," or as in "right here, to the left"? Well, whatever. These steaks are only okay.

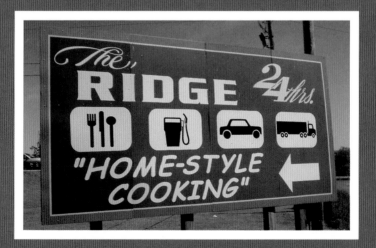

This restaurant offers cooking just like someone's drug-addled mom used to make.

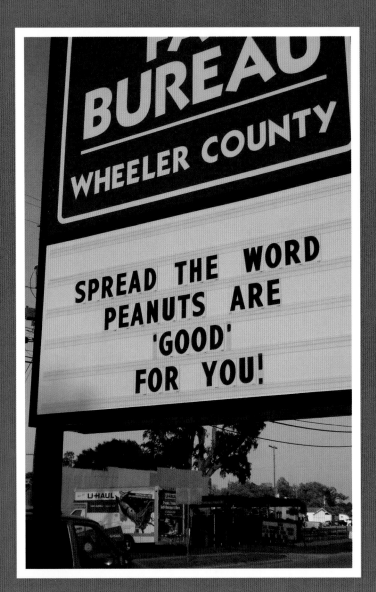

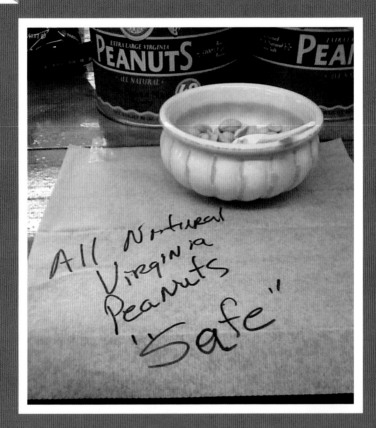

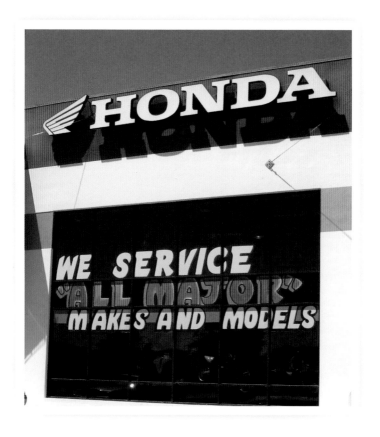

Their definition of "all" and "major"
may be different from yours.

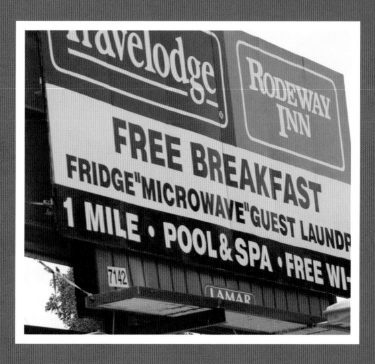

"Microwave" is hotel lingo for "nonfunctioning TV."

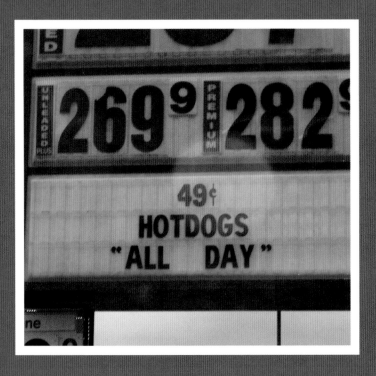

Hot dogs available during certain hot dog hours.

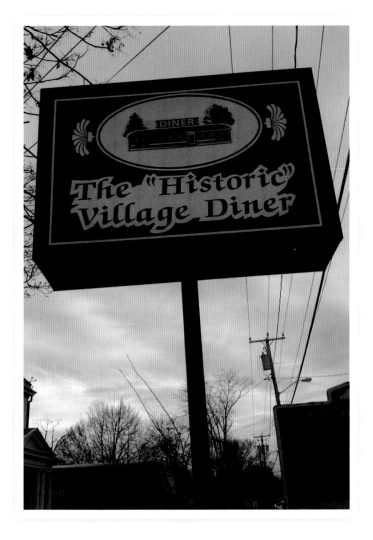

It's "historic" if you take the word's literal meaning:
"built at some point in time."

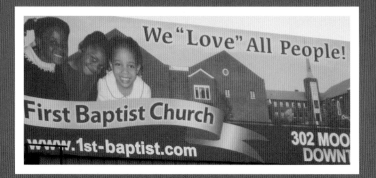

Just "love" them all over the place.

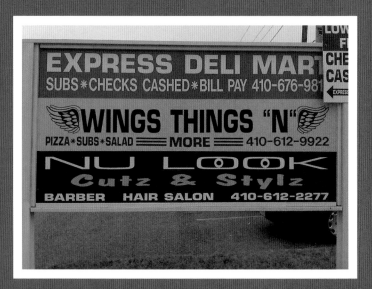

Makes you wonder where Wings Things "A" through "M" are located.

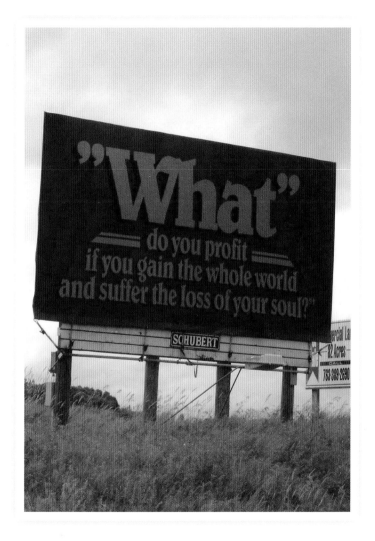

"What" is a word you might say upon seeing
how this sign is punctuated.

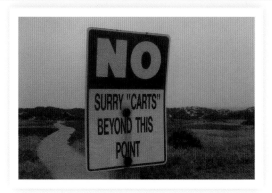

"Carts" here is a euphemism for something more exciting—probably dirt bikes.

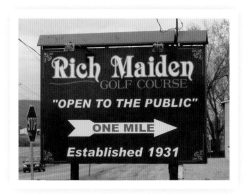

"Open to the public" does not necessarily mean that YOU are good enough to come here. I mean, obviously.

C130036

FRESH
BROWN
" EGGS "

They came out of a chicken's rear end, so that makes them eggs, right?

As you're driving along, pay attention to the vehicles and smaller signs around you—they are hidden treasure troves of quotation mark abuse!

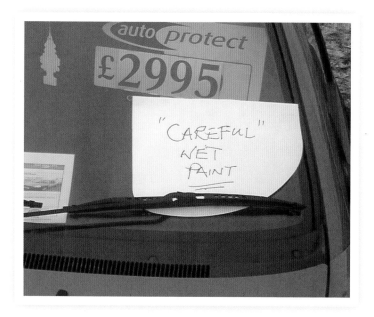

Please get this paint all over yourself.
They're talking to you, ladies!

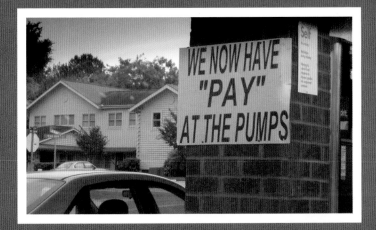

Now you don't have to come inside to steal gas.

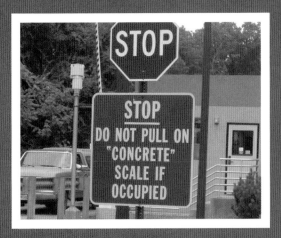

If you pull on it, you might find out it's not made of concrete.

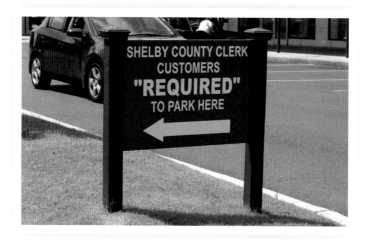

Okay, not if you walked.

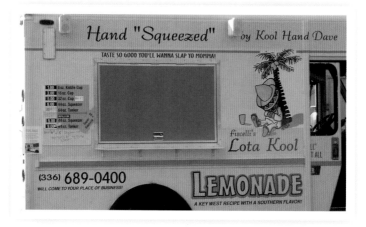

What are those guys really doing to the lemons?
Fondling? Pinching?

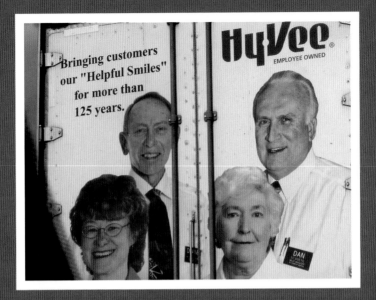

Those smiles sure do look "helpful."

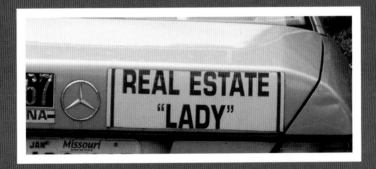

When it comes to price negotiations,
she doesn't seem so ladylike.

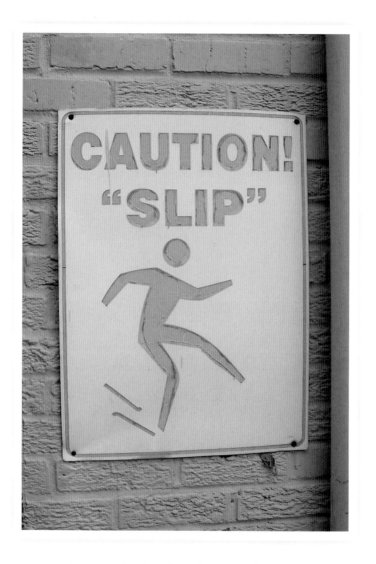

Look out for Freudian slips near this sign.

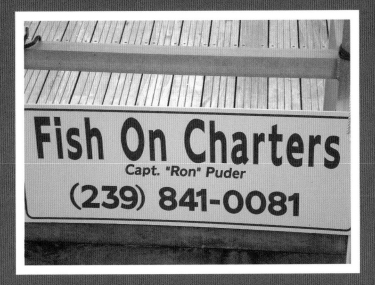

Capt. "Ron's" real name is probably a girl's name.

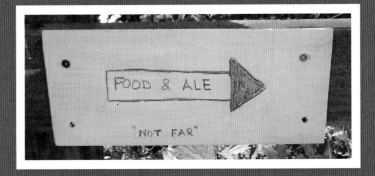

You're never getting to the food and ale.
NEVER! BWAHAHAHA!

IF IT "DOES

ON THE

"PICK

So just leave things on the floor,
in other words.

"T" BELONG

FLOOR

T UP"

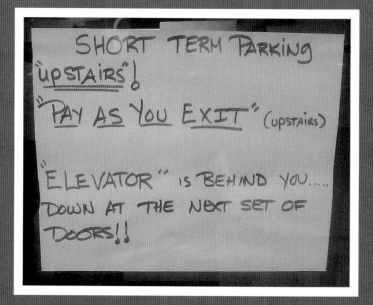

You're never going to "exit," since the "elevator"
is an empty shaft that will plunge you to your death.

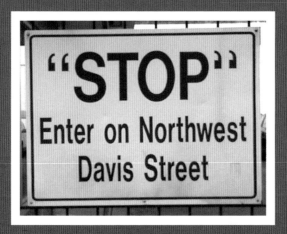

"STOP"
Enter on Northwest
Davis Street

This sign is daring you to ram through the gate.
Hear that? That's the sign calling you a wimp.

"Push Green Button for Ticket"
"Please take ticket with you"
"Please pay at parking pay station
when exiting"

"Thank you"

This sign commemorates a great conversation
some people had here once.

Do "<u>NOT</u>"
PARK here
Please

THESE PARKING
SPACES ARE FOR

"<u>CUSTOMERS</u>"

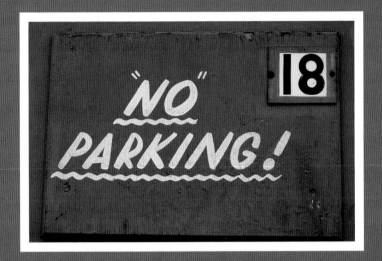

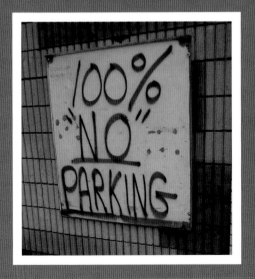

JUST KIDDING! PLEASE PARK HERE, I INSIST.

"UNNECESSARY" QUOTATION MARKS

IN THE

" BATHROOM "

"The facilities" are frequently full of passive-aggressive commentary and statements of the obvious. Inevitably, some "rest" rooms use the opportunity to create subtle innuendo through the use of punctuation.

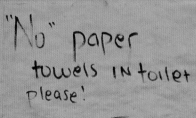

Okay, a few.

ATTENTION

If commode does not "flush" automatically, please push the black button to flush commode.

Thank you for your co-operation !

The automatic "flush" leaves something to be desired.

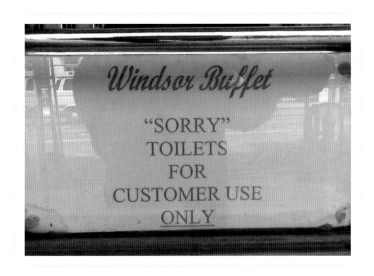

Windsor Buffet

"SORRY"
TOILETS
FOR
CUSTOMER USE
ONLY

You can just hold it and we are not really sorry.

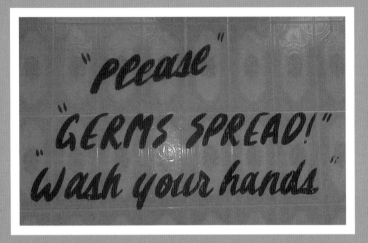

This bathroom offers a little dialogue for you to perform with your fellow bathroom visitors.

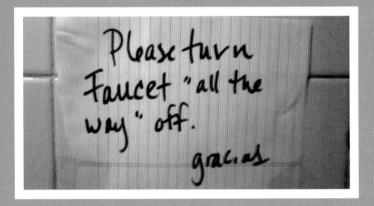

Naturally, you shouldn't turn it so far that it actually comes off.

--CAUTION--

"HOT"

"HOT" WATER IS VERY "HOT"

The water that is labeled "hot" is labeled "hot" because it is "hot." Did you know?

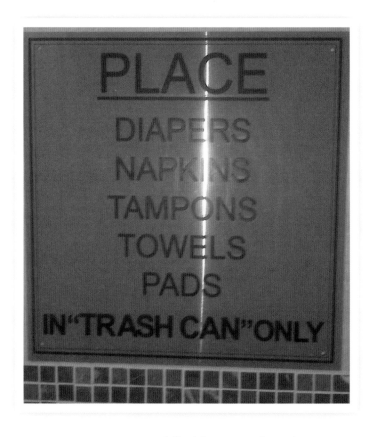

PLACE
DIAPERS
NAPKINS
TAMPONS
TOWELS
PADS
IN "TRASH CAN" ONLY

I mean, once it's full of diapers and towels,
can you really call it a "trash can" anymore?

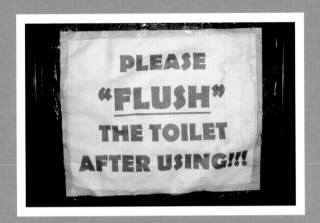

Please pantomime flushing the toilet.

Oh, did we say toilets? We meant "receipts."

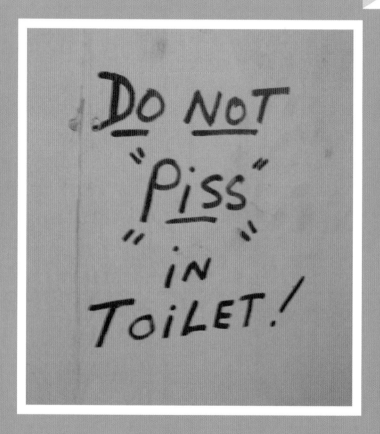

Tinkling and taking a leak, on the other hand,
are totally acceptable.

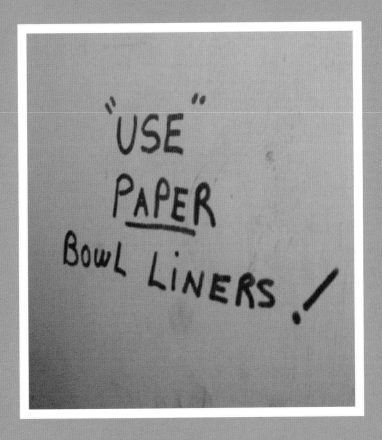

"USE" PAPER BOWL LINERS!

You can just imagine you've used them, if you like.

"UNNECESSARY" QUOTATION MARKS

" "

SOCIAL GRACES

Being a good "friend," "neighbor," "sibling," "child," "tenant," and "acquaintance" is hard. Harder still is interpreting what the people in your life are trying to tell you at any given moment through the guise of politeness.

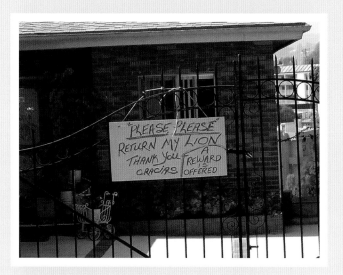

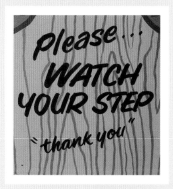

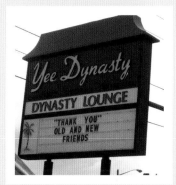

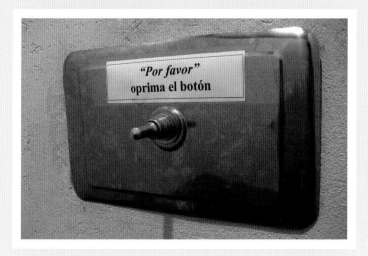

. . . AS YOU CAN SEE, ALL OF THESE PEOPLE ARE
"REALLY" "SINCERE."

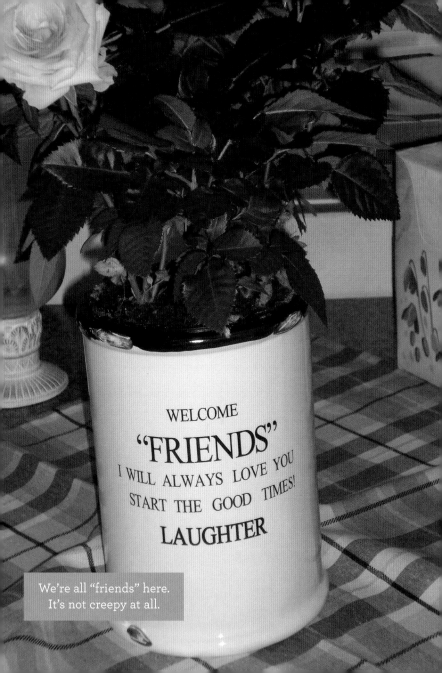

WELCOME
"FRIENDS"
I WILL ALWAYS LOVE YOU
START THE GOOD TIMES!
LAUGHTER

We're all "friends" here.
It's not creepy at all.

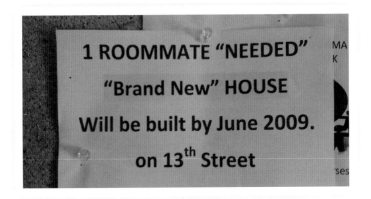

1 ROOMMATE "NEEDED"

"Brand New" HOUSE

Will be built by June 2009.

on 13th Street

You know, we don't "need" roommates really,
we just want one—we can quit anytime.

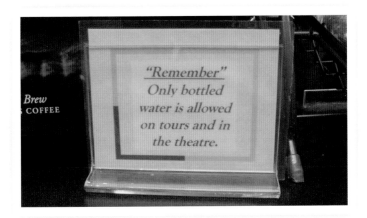

"Remember"
Only bottled
water is allowed
on tours and in
the theatre.

Brew
COFFEE

They are pretending that you already knew that.
This way they seem less like jerks for telling you to
leave your burger outside.

USED MOWE

AND "MORE

SALES AND SE

963-80

They have used mowers
and more used mowers.

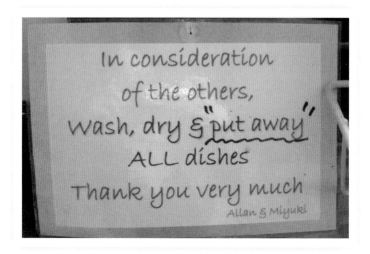

Activities that may qualify as "putting away" dishes:
breaking, hiding, and putting more food on them.

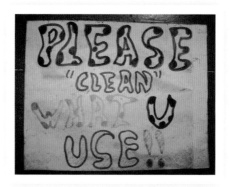

This sign is giving you license to do a poor job
of cleaning the things that you use.

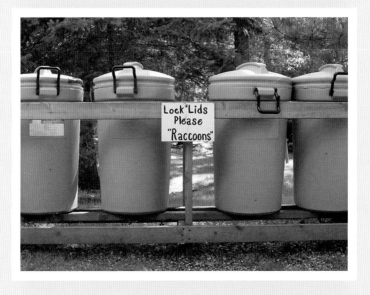

In this neighborhood, the polite term for hobos is "raccoons."

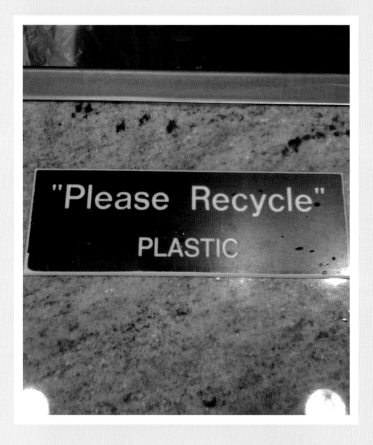

Yep—sure sounds like something Plastic would say.

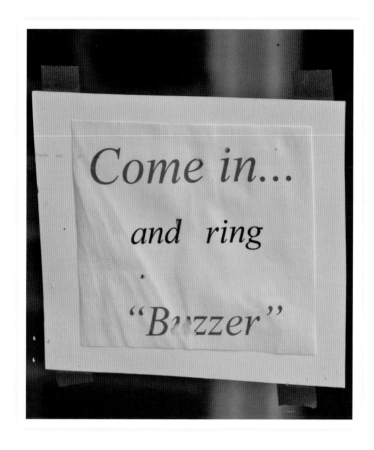

This "buzzer" makes a variety of nonbuzz sounds.
Like awoooogas and fart noises and "La Cucaracha."

Parking for Commissariat House

"*Garden Party*"
at rear of building

The Commissariat is known
for his mind-blowing raves . . .
er . . . "Garden Parties."

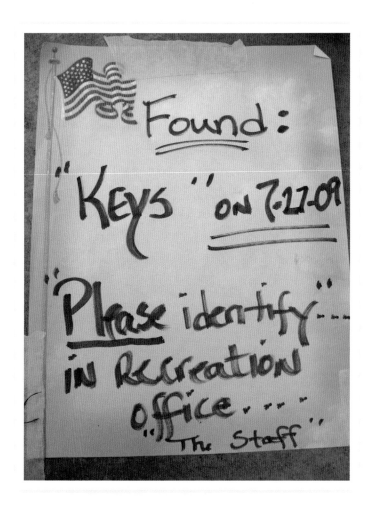

Because of the artful use of quotation marks, this sign can
be tailored to apply to lots of things lost on 7-27-09, not just
keys. For instance, "keys" could just be slang for puppies.
Or identities.

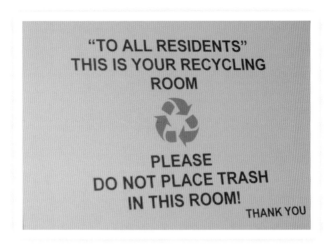

"To All Residents" is such a classic poem.
That's why they put it on the wall.

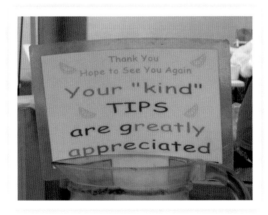

Just tip us, you jerks.

"Welcome
MONTECITO-SEQUOIA

"It's paradise."

"UNNECESSARY" QUOTATION MARKS

" "

SEASONAL

Sometimes a special occasion demands special punctuation. And the good ol' quotation mark is here to make all your seasonal greetings delightfully ambiguous.

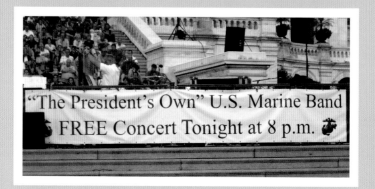

Well, in a manner of speaking,
they belong to the whole country.

Now being held on the 23rd of November.

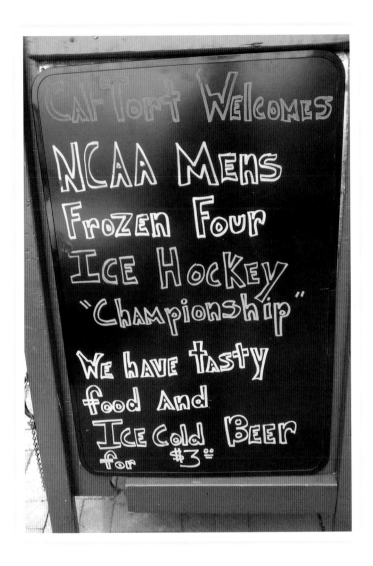

If you call hockey players champions.

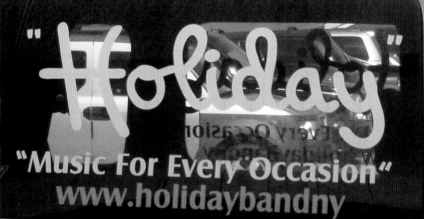

Every day is a fake holiday
when you pay money for it.

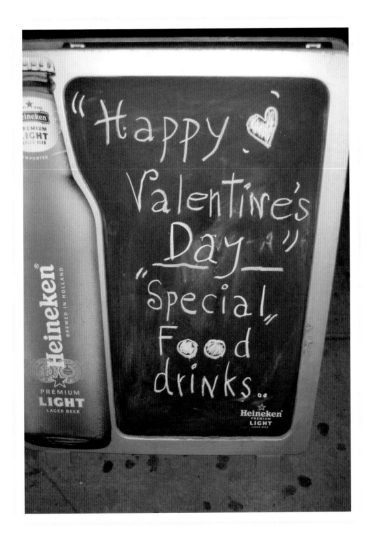

Those "special" "Valentine's" drinks
"don't" have roofies in them.

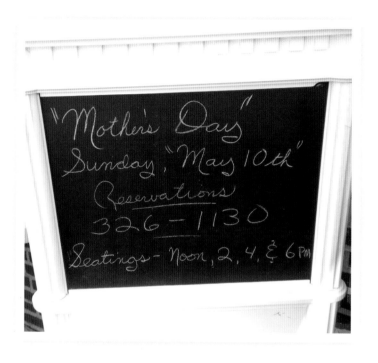

It's fine, just tell your senile mother today is Mother's Day—
she won't know you forgot.

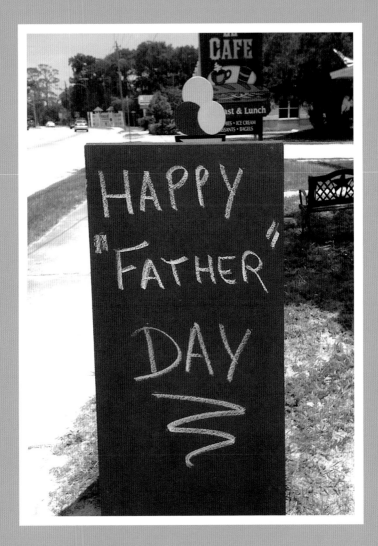

Nothing says "Happy Father Day" like
doubt about paternity!

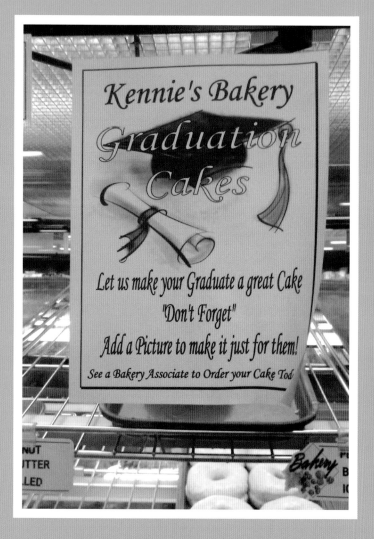

"Remember" that time you thought a photo on a cake
was appetizing?

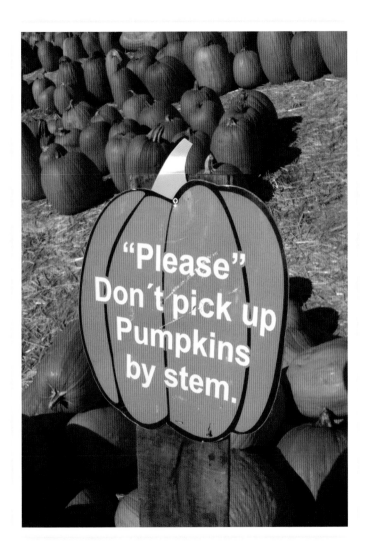

We don't really want to be polite about this.

Sometimes people hedge their bets on religions by putting the important figures in quotation marks.

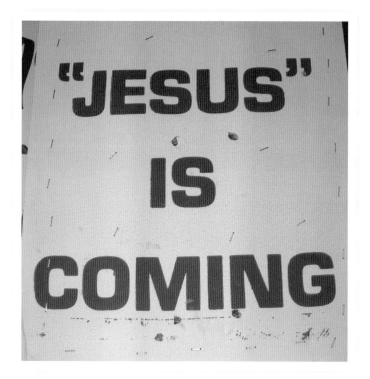

"JESUS" IS COMING

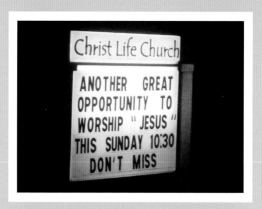

Christ Life Church

ANOTHER GREAT
OPPORTUNITY TO
WORSHIP "JESUS"
THIS SUNDAY 10:30
DON'T MISS

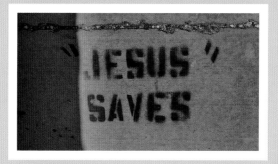

"JESUS"
SAVES

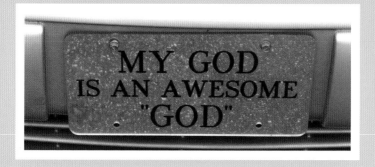

MY GOD
IS AN AWESOME
"GOD"

"UNNECESSARY" QUOTATION MARKS

MISCELLANEOUS

There are some instances of unnecessary quotation marks that defy categorization. Embrace the mystery.

NO "STUDENT"
"PARENT"
ALLOWED
BEHIND THE
COUNTER

No role-playing allowed behind
the counter in this establishment.

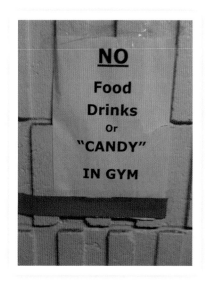

Certain schools have strict "no drugs in the gym" policies.

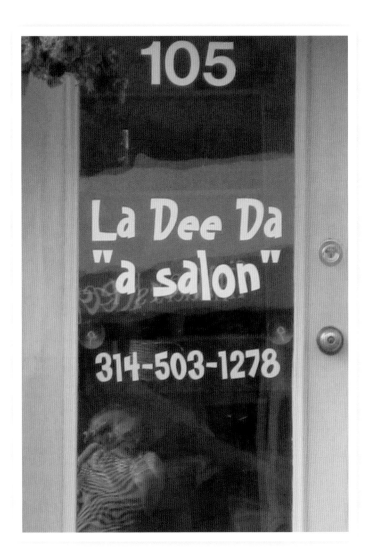

A pretend salon.

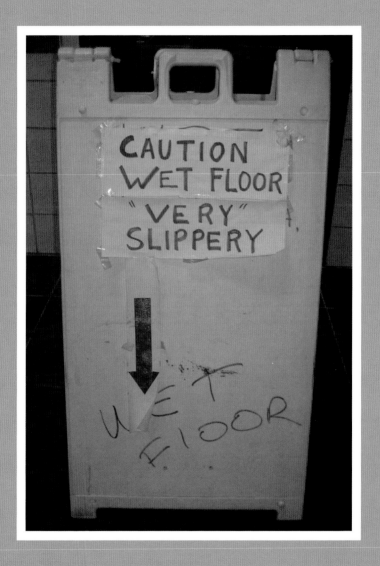

You wimps. It's actually just somewhat slippery.

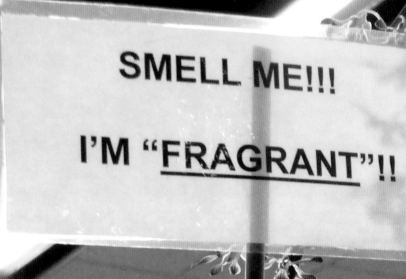

SMELL ME!!!

I'M "<u>FRAGRANT</u>"!!

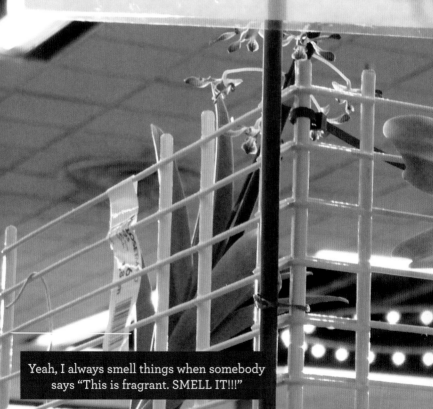

Yeah, I always smell things when somebody
says "This is fragrant. SMELL IT!!!"

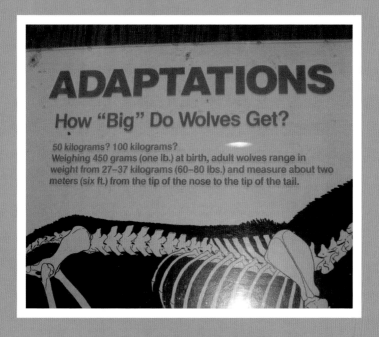

ADAPTATIONS

How "Big" Do Wolves Get?

50 kilograms? 100 kilograms?
Weighing 450 grams (one lb.) at birth, adult wolves range in weight from 27–37 kilograms (60–80 lbs.) and measure about two meters (six ft.) from the tip of the nose to the tip of the tail.

Does size matter for wolves?

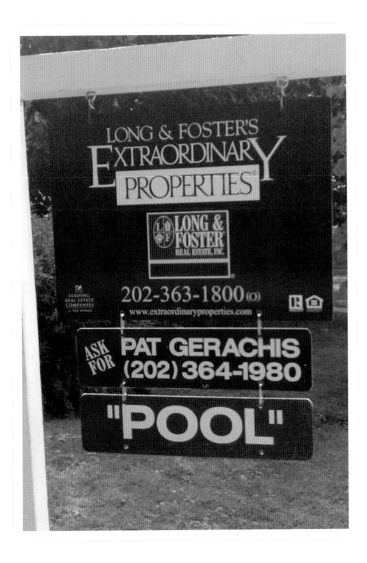

A flooded basement isn't technically a pool.

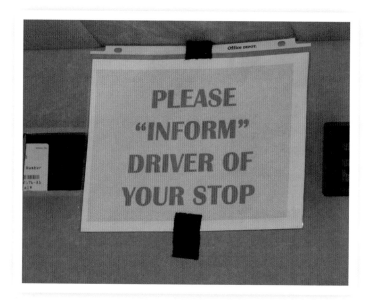

Possible ways to "inform" a driver of your stop:
think it at her, make a small gesture, or write a note
in Braille and leave it on your seat.

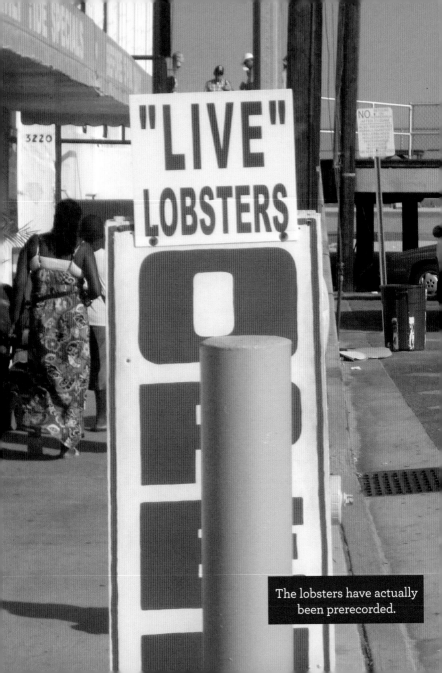

"LIVE"
LOBSTERS

3220

The lobsters have actually
been prerecorded.

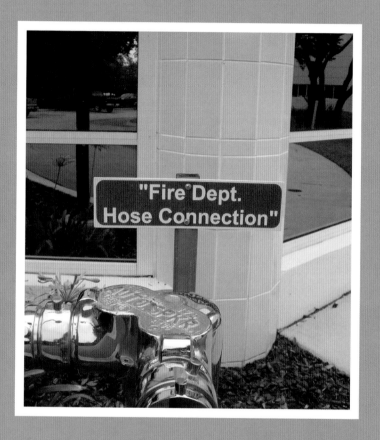

Sure . . . it's the hose connection. For the fire department.

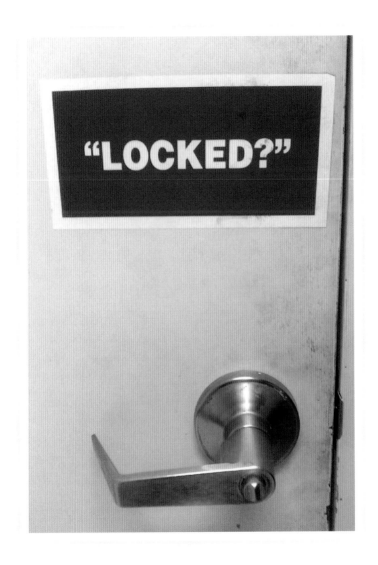

Or is it? Just kidding. Or am I?

THE USE POSSESSION ADN
SALE OF DRUGS IN MEXICO
IS PROHIBITED BY "LAW"

Either Mexican "laws" are very flexible or "Law" is the nickname of a vigilante who enforces drug trafficking south of the border.

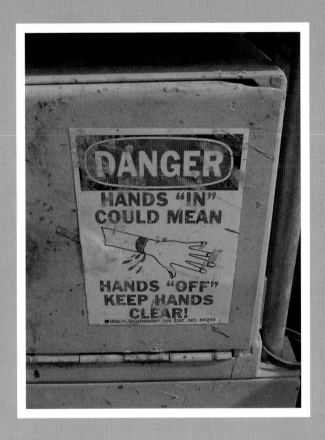

Nothing says "we take our workers' safety seriously"
like dismemberment puns!

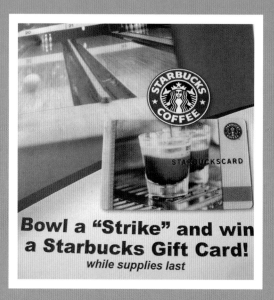

Cheat at score keeping, win a gift card.

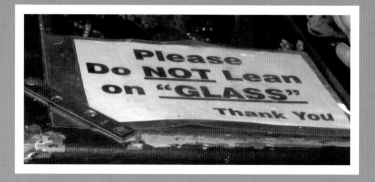

Or whatever this is—it sure smudges like glass.

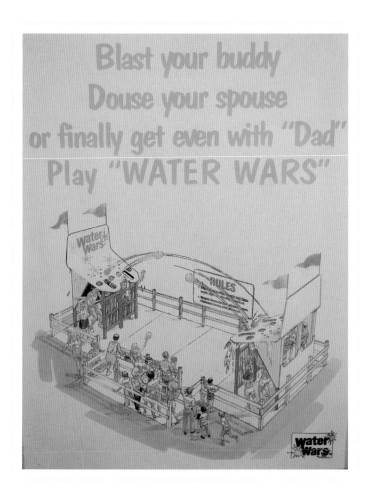

Finally get even with that guy you think is your dad.

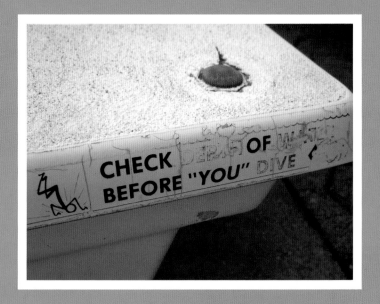

Check to make sure the water is as low as possible before
pushing someone off the diving board.

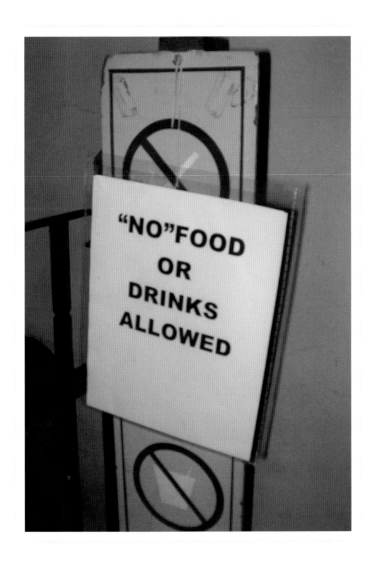

Some food or drinks allowed.

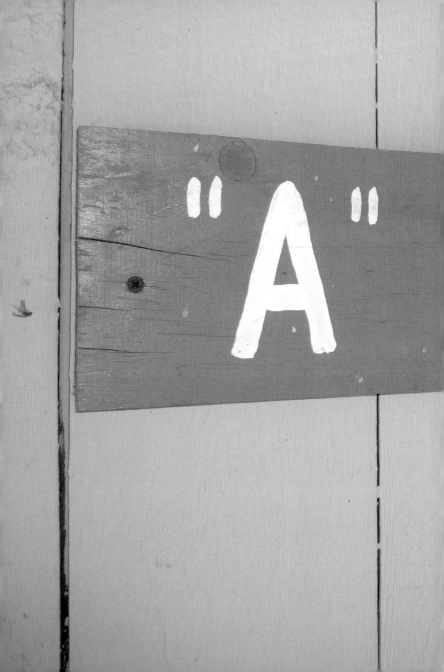

BLDG.

Really, it's "THE" bldg.

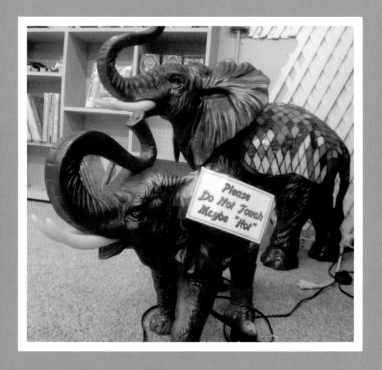

There's nothing quite as "hot" as stained glass elephants.

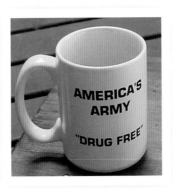

We are just going to not ask and not tell who is doing drugs.

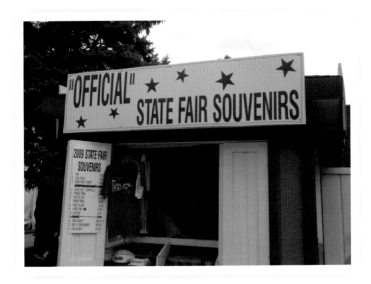

These souvenirs have "something" to do with the state fair.

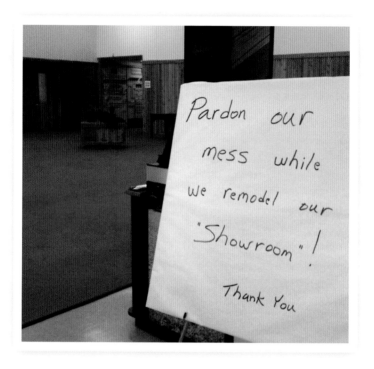

A good place to "show off" horrible wood paneling
and ugly brown wall-to-wall.

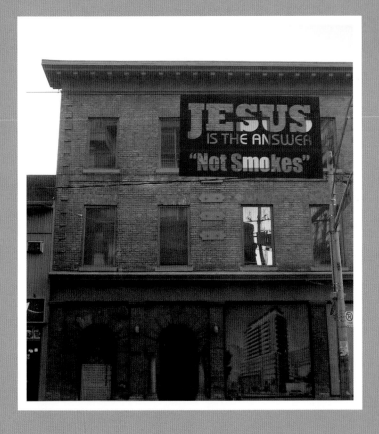

It kind of depends on the question, right?

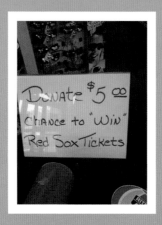

If you call that winning.

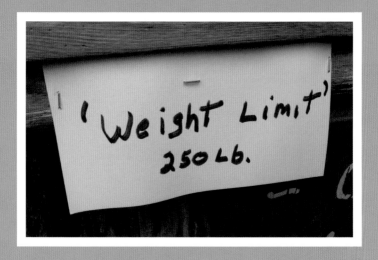

Hey, is that a fat joke?

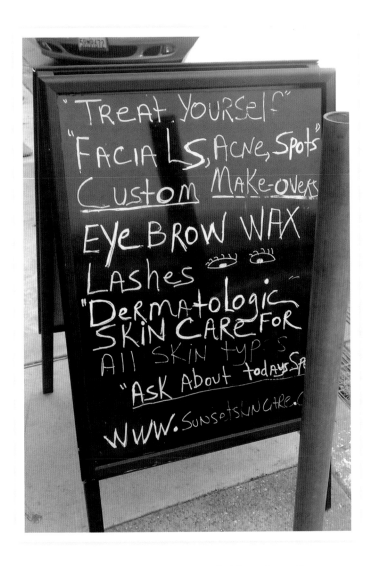

Acne AND spots? Sure sounds like a "treat."

ACKNOWLEDGMENTS

The opportunity to work on this book is just one example of the ways one punctuation mark has made my life strange but also fun. I would like to express my appreciation for some of the people who made it possible for this book to be produced.

I am blessed with so many family members and "families" who keep me sane (usually) and deserve my thanks for any successes I have. My parents, Robert and Laura, whose excellent sense of humor I inherited, have been helpful and supportive on all of my projects. My siblings, Meredith, Bryan, and Lynnae, are also pretty funny and awesome. I'm glad to be marrying Justin Jonker, who helps me come up with jokes, keeps me from stressing out, and loves me even when I'm annoying. Speaking of people who put up with me when I'm annoying, thanks to my roommate Jamie Landau, my officemates in Terrell Hall 226, and the rest of my academic community at UGA. Y'all rock. Thanks also to my church family in Athens, Georgia, and to my new in-laws, the Jonkers.

I owe a serious debt of gratitude to my literary agent, Kate McKean; my editor, Emilie Sandoz; Jacob Gardner; Erin Thacker; Becca Cohen; and the other fine professionals at Chronicle Books. All of these people are very good at their jobs and make mine easier.

Finally, huge thanks to the thousands of Internet strangers who read the "Blog" and send me their pictures. Without all of you, this book would literally not exist. This is especially true of the hundreds of people whose high-quality, high-hilarity finds appear in this book. Their names, and a few whose images got cut, are found here. Working on this book and maintaining the "blog" has taught me that strangers can be generous, funny, and encouraging. Even on the scary Internet. Thanks for that.

CONTRIBUTORS

Douglas Aldridge
Alastair Alexander
Peter Allendorfer
Gene Anderson
Michelle Atkins
Adrian Bailey
Lelah Baker-Rabe
Kate Baldwin
Kristin Bamberger
Cassie Barnum
Turi Becker
Benjamin L. Begley
Bethany Benzur
Brian R. Bernardini
Sean Biehle
Jill Blaeser
Angela D. Blair
Kate Borders
Bob Bowden
Kristen Brown
Matthew Budman
Sarah Bunker
Alexander Burun

Darren Bush
Steven Camilli
Brenda Campbell
Jen Carmichael
Alex Carmichael
Blake Carver
Joey Cavella
Jason A. Cerrato
Sarah Chverchko
Kathryn Clagett
Andy Clinton
David E. Cochran
Bill Cokas
Hannah Coleman
Diane Cousineau
Krista and Karen Cukrowski
Meghann M. Cuniff
Pedro Curi
Carlos d'Abrera
Ron Davis
Danny Davis
Susan Debacker
Jeff Demetriou

Erin Demund
Gregor Dodson
Claire Donnelly
Ryan "M" Donovan
Weston Dulaney
Meg Eckman
Maureen Egan and
Matthew Barry
Robin Eiseman
John Eklund
Emily
Kristin Engel
Maggie Enright
Jamye Evelyn
Jennifer Faer
Wylie Fisher
Benjamin Flight
Ela Majikfaerie Forest
Katharine Foster
Janella Fox
William Fraser
Cheryl Freer
Bill Fuhry
David Galloway
Valerie Gartland
Erik Gensler
Susie Ghahremani
Michael Gorman
Margo Greenlaw
Christa Grieco
Natalie Guest
Paul Hallows
Jennifer A. Hanscomb
Caroline Harris
Ethan Hazzard-Watkins
BJ Heinley
Benjamin Hill

Jon Hoffman
Eric Homan
Marcy K. Hosket
Camille Janer
Neal Jennings
Kiersten Jeske
Anne DeMarsh Johnson
Richard Johnston
Emily Jones
Rusty Kahl
Blake Kanewischer
Jennifer Karmel
Meredith Keeley
Jonathan Khoo
Penelope Klein
Sarah Baird Knight
Terry Lee Knight
Simone Kovago
Eric Kramer
Sara Kruger
April Krukowski
Jonathan Kunberger
Jennifer Lambert
Mandy Langston
Joshua W. Levy
Danielle Lindemann
Lisa
Joey Litman
Jennifer Madsen
Ryan Mallady
Joanna Mang
Mindy Maris
Barry D. Marsh
Tim Masterton
Drew Maust
Eileen McAuslan
Margaret McDonald

Stacey McLachlan
Katy Miller
Alison J. Mills
Caron Mitchell
Karen Moore
Heather Mroczkowski
Ariana Myers
Karin Myhre
Amanda Nelis
Michelle Neuman
Jeff Newton
Matthew M. Nordan
Danielle Nuchereno
Nick O.
James Page
David Paris
Kay Partain
Tom Partington
Katie Pegoraro
Angela Perkins
Bettina Pickett
Bryan Pohl
Lorie Popp
Nicole Reader
Bill Rehm
Sarah Reid
Meredith L. Reynolds
Laura Rheinheimer
Jeff Richards
Carson Rittel
Hayley Heller Ritz (Jenny's Mom)
Guillaume Roberts
Leah Rodgers
Jason Rose
David G. Rupert
Alex Schiller
Angela Schneider

scrabblehound
Jennifer Shepherd
Deanne Schulz
Bianca Siegl
David Silverstein
Aksel Inge Sinding
Ofer Sivan
Zach and Brittany Smith
Liz Smith
Kimmy Snyder
Logan Sobonya
Cina Sorensen
Karie Spaetzel
Pat Spellman
Lori Stelma
Molly Beth Strijkan
Sully Syed
Angela T.
Jacqueline Temkin
Amanda Terkel
Kayla Terry
Mica Wickersham Thomas
Matthew Thompson
Ric Timmers
John and Stephanie Tornblad
Rhonda Treptow
Audra Valaitis
Ryan Valerie
Rachel VanZanten
Keylin Visockis
Colin Walmsley
Lucas Whitestone
Tom Wilson
Tracy Windt
Elisabeth Witt
Carrie Zahniser

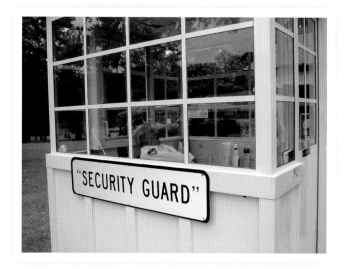

Documenting and sharing your quotation mark finds keeps all of us "safer."

ABOUT THE AUTHOR

Bethany Keeley is a graduate student, blogger, and writer who lives in Athens, Georgia, with her new husband and her cat, Zeus. She started the "Blog" of "Unnecessary" Quotation Marks in 2005 and frequently updates it at www.unnecessaryquotes.com.